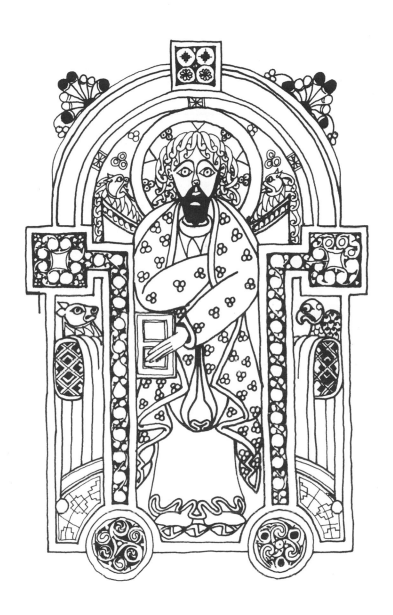

EXPLORING

the book of kells

First published 1988 by The O'Brien Press Ltd.,
20 Victoria Road, Dublin 6, Ireland
Copyright © The O'Brien Press
Reprinted 1989

British Library Cataloguing in Publication Data
Simms, George
Exploring the Book of Kells
1. Irish illuminated manuscripts in Latin:
Book of Kells
I. Title.
091
ISBN 0-86278-179-5
Illustration p.1: Portrait of Matthew (see p.47 for description)

Layout and design: Michael O'Brien
Typeset at The O'Brien Press
Printed by Proost, Belgium
10 9 8 7 6 5 4 3

EXPLORING
the book of kells

GEORGE OTTO SIMMS

Drawings

DAVID ROONEY

Book of Kells Details

EOIN O'BRIEN

THE O'BRIEN PRESS

DUBLIN

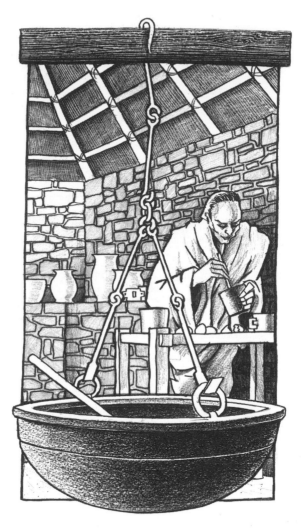

A Note

*The numbers of the leaves of the Book of Kells, (for
example f. 34r), refer to the pages (or folios) of the Kells
manuscript. The letters r and v are added; r refers to
right-hand pages and v to the left-hand (r stands for
the Latin word recto — the front of the leaf, and v for
the word verso, the back of the leaf).*

Contents

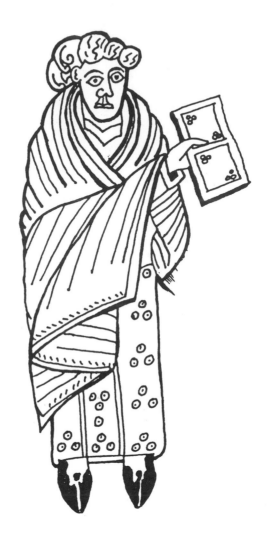

*This figure, fair-haired and clad
in a purple robe, stands in the left-hand
margin of the opening of St Matthew's
Gospel. The word 'book' fills this page. The
monk is presenting the book.*

PART 1

THE MAKING OF THE BOOK OF KELLS

Who Made the Book of Kells?

The Book of Kells is a very precious book, written many hundreds of years ago, around A.D.800. It is a book of the gospels, written by hand and beautifully illustrated with colour pictures.

We do not know the names of the writers of the book. There are signs, as we turn the pages, that more than one person wrote it. It is possible to detect changes in the style of handwriting as we read on.

Nor do we know who painted the pictures in the book. There is so much variety in the decoration that we can be sure that several artists worked on the designs.

MONKS

We do know that the book was made in a monastery. A monastery was built by a small group of people who felt as Christians that God wanted them to do special work for him. These people were called monks because they chose to leave their homes and family life and to start their lives afresh, 'away from it all', in a quiet secluded place.

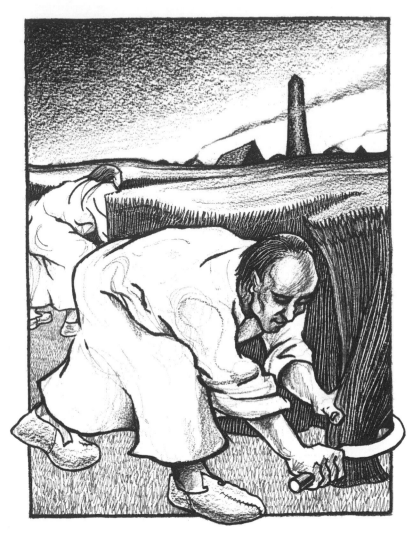

Monks at work on the monastery farm until the bell from the round tower summons them to prayer and then to study.

The word 'monk' suggests a life spent alone. Actually, monks together shared a special life of prayer and reading and working with their hands. They were alone - away from the ordinary world - but never lonely. There were separate monasteries for men and women.

If you get the chance to visit that rocky island called Skellig Michael, off the coast of Kerry, you will find a row of huts, shaped like beehives, and nearby a little church. The huts in a monastery were called 'cells'. Each monk usually had his or her own cell for prayer and study and also for sleeping in at night. The monks would meet together for worship in the little church.

Monks lived to a very strict timetable. They had a rule, for example,of meeting together for prayer seven times each day. They also made promises to God that they would stay as monks for life. We are specially interested in their life of reading and study. We know that they also wrote books and made copies of the psalms, which they loved to sing. They also copied the four gospels of the New Testament, which tell the story of the life and work of Jesus Christ.

Soon the monasteries became well known not only for their life of prayer but also for the work which the monks produced. They learned how to make many clever and skilful things. They were builders. They farmed. They fished. They kept bees - and they wrote books. The monks did everything themselves.

SCRIPTORIUM

Monasteries became larger later on. Many more buildings were added. A special room or cell was sometimes built for the work of writing. A monk, called a 'scribe', sat in the quiet peace of this writing room, which was called a 'scriptorium'. Here they shaped the letters of the words they wrote with a clear script, well-rounded and flowing.

The art of writing made the monasteries famous not only in Ireland, Scotland, Wales and England, but also in many countries of Europe. The books they wrote were very precious and valuable. It took a long time to make these books. Each time a book was needed it had to be written out completely by hand! Printing had not been invented. Only handwritten manuscript books, copied with great labour, were in the libraries and the schools for reading and learning until the fifteenth century.

The first printed book came off the printing press about the year 1456. The printed letters looked very like the handwritten script of that time. Copies of books, of course, from that date were much more easily produced. Great numbers of bibles, for example, were much more quickly published and distributed.

THE WORK OF THE SCRIBE

Writing was hard work. One monk, from Ireland, has left us a piece of poetry he wrote in the Irish language. In these verses he has told us what his feelings were like as he sat at his desk, writing well into the night. For him the work of a scribe was really tiring. He had to concentrate. Each letter of each word had to be well shaped, so that it could be easily read. He could never be careless or sloppy.

Some writers found their work exciting. The making of copies of a book was not, in their opinion, a dull chore. One scribe said it was like going on a journey. His pen travelled over the surface of the skin as he wrote. The writer of the Irish poem below says that 'hunting words' was something he enjoyed. He thought that as he searched for the word he wanted to copy out, he was like a hunter after a bird or a hare, looking through the mist across the fields or into the trees, before he caught sight of the animal.

This scribe was very glad to have a friendly white cat beside him as he wrote. He saw that the cat also had work to do. The cat hunted mice, while his master, the scribe, hunted words. This is his poem, translated into English from the old Irish language of a thousand years ago. It was written on the lower half of a page of a grammar book, now in a monastery in Austria. The cat's name, Pangur Bán, is used as the title of the poem. The two words *Pangur* and *Bán* both mean 'white': Pangur Bán must have been a very white cat indeed, 'whiter than ordinary white'.

Pangur Bán

I and Pangur Bán, my cat,
'Tis a like task we are at;
Hunting mice is his delight,
Hunting words I sit all night.

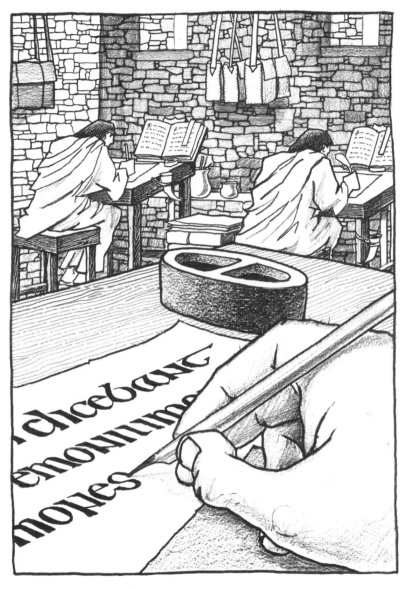

The scriptorium (writing room).
Scholars, quill in hand, copy the scriptures. Book satchels
hang overhead. The well-rounded letters are shaped in
the 'house style' of the Irish monasteries.

Better far than praise of men
'Tis to sit with book and pen;
Pangur bears me no ill will,
He too plies his simple skill.

'Tis a merry thing to see
At our tasks how glad are we,
When at home we sit and find
Entertainment to our mind.

Oftentimes a mouse will stray
In the hero Pangur's way;
Oftentimes my keen thought set
Takes a meaning in its net.

'Gainst the wall he sets his eye
Full and fierce and sharp and sly;
'Gainst the wall of knowledge I
All my little wisdom try.

When a mouse darts from its den,
O how glad is Pangur then!
O what gladness do I prove
When I solve the doubts I love!

So in peace our tasks we ply,
Pangur Bán, my cat, and I;
In our arts we find our bliss,
I have mine and he has his.

Practice every day has made
Pangur perfect in his trade;
I get wisdom day and night
Turning darkness into light.

Translation: Robin Flower

Two Monasteries

We think of two monasteries in connection with the Book of Kells: the monastery of Iona, off the west coast of Scotland and the monastery of Kells in County Meath. Both seem to have had a share in the making of the Book of Kells.

IONA

Iona is a small, wind-swept island among the inner Hebrides. It is 3 1/2 miles long and only half-a-mile wide. It is about one mile from the larger island of Mull.

St Columba (also known as St Colmcille) sailed from Ireland to Iona in the year A.D.563. He had founded many monasteries in Ireland, including Durrow, near Tullamore, right in the centre of Ireland, and also Derry, on Lough Foyle. Now he wanted to go into the wider world for Christ. He chose to be an exile.

Many people think that the Book of Kells may have been written in Iona. There are two reasons for this suggestion: first, Columba loved to copy the scriptures and he taught others how to make copies also. Secondly, there was a close connection between Iona and Kells.

Some two hundred years after the death of St Columba, the island of Iona was invaded by Norsemen who came across the seas from Norway to rob the island-monastery and destroy the buildings. The abbot, who was the chief monk in charge of the monastery, escaped to Kells in Ireland and made Kells an important centre of what was known as 'Columban' monastic life.

It has been said that the Book of Kells might have been planned as a very special luxury copy of the gospels to celebrate, in the year A.D.797, the two-hundredth anniversary of the death of St Columba. He had served God and the Church in Iona for thirty-four years until the date of his death on 9 June, 597.

13

There are many fishing stories told in Adomnán's Life of St Columba. This sea-bird's-eye view of the crew recalls some wonderful catches.

The story of Columba's life has been written by Adomnán or Eunan, who was abbot in Iona about eighty years after Columba. Adomnán gives us a lively account of Columba and his books. Columba seems to have lived for this most important work of copying the scriptures. Iona was a place of education and it was also a starting point for many missionary journeys. The Christian faith spread from Iona in different directions — out to Iceland, to the land of the Picts in north Scotland, and to Northumbria in the north of England.

Iona was also visited by many monks and students from other monasteries. Although the island was eighty miles from the coast of Ireland, many journeys were made between Ireland and Iona. It was often easier in those days to travel by ship across the sea than to make a journey overland between one monastery and another, as roads were rough and dangerous. Iona was easily approached and was often visited.

Iona could also, of course, be invaded by enemies - robbers and adventurers seeking their fortune. Some monasteries suffered attacks from sea-rovers from Scandinavia who swooped down on them. Many of the monasteries' treasures of gold and silver sacred vessels, including chalices and church ornaments, were plundered. Monks often lost their lives during these invasions.

We can capture the atmosphere of the island of Iona when we read about Columba. He had a warm personality and he called all the monks in his monasteries his 'family'. He was a father-figure, and as the name 'abbot' tells us he was a fatherly leader of the community. He loved animals also. There is a lovely story about a crane which flew into Iona and was cared for with great tenderness by Columba. There was a very special white horse that worked on the farm and was devoted to the saint. This horse used to carry the milk vessels between the cow pasture and the monastery and in the last days of Columba, shortly before he died, we read that the horse 'went to the saint, and, strange to tell, put its head in his bosom, knowing that his master would presently depart from it.'

We are not surprised that the love of animals can be seen in the books produced by the 'Columban' school of writing such as the Book of Kells.

We discover also how Columba took great care of the books in Iona. We read that he shouted 'Take care, take care, my son' to one member of the community when he saw that the book which his pupil was studying was going to fall into a jug full of water. There were anxious moments, also, when 'the horn that holds my ink' was nearly upset. The books were kept in skin satchels and used to hang up on wooden pins along the wall, instead of having a place on shelves or in cupboards. After the wind had blown hard on a stormy night, the monks would ask one another: 'Did you hear the library?', as all the satchels swayed and rattled in the breeze!

Columba had a very strong singing voice. When he sang the psalms, he could be heard at a great distance, 'sometimes as far as a thousand paces'. He was very hospitable and loved to greet his guests, washing their feet and making them comfortable. He himself had a bed of bare rock and a stone for a pillow. He had a high standard when there was any writing to be done. He encouraged the scribes to take great care, to read through what they had written and always make the necessary corrections.

At the very end of his active life, Columba was still writing. This time, he was too ill to finish and his hand grew weak. He asked his companion, Baithene, to take his pen and finish the psalm for him. The last words that Colmcille wrote have often been remembered. They are from Psalm 34 and they seem to tell us about the personality of this lover of books. He wrote: 'They that seek the Lord will never lack anything that is good,' and all in the community felt that the father-abbot himself would soon go and seek the Lord, and that the end of his earthly life was near.

KELLS

Although Columba died two hundred years before the Iona community moved to Kells, the influence of the saint lived on. In the pages of the Book of Kells, we can see signs of careful copying, clever corrections of misspellings and almost invisible mending of mistakes, reminding us of his careful guidance. The pictures remind us of Columba's love of birds, horses, dogs, cats and many other creatures found on and off the island, including many sorts and shapes of fish.

We know from early history a little about the disaster that fell upon the community in Iona. The buildings were burned and

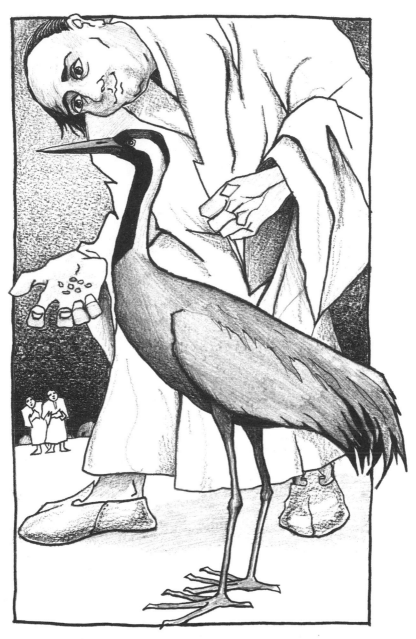

A crane, arriving at Iona 'very tired and weary' as a guest from Ireland, became one of Columba's favourite pets.

Some two hundred years after Columba's death in A.D. 597, long,
low ships, sailing from Norwegian shores, invaded Iona. We read
of raids and robberies in A.D. 795 and again in 803. The abbot,
Cellach, fled with his surviving companions and,
starting community afresh in Ireland, built a
monastery at Kells, County Meath.

destroyed. The move was made back to Ireland and at Kells the life of the monastery began afresh.

THE BUILDINGS AT KELLS

The monastery built at Kells in the ninth century, probably had many buildings. Inside the enclosure, made of embankments of earth and stone walls to give protection against wild animals and enemy intruders, lived a large community.

The church would have been in an important position. A refectory or dining-room, with a kitchen nearby, was large enough to allow the monks to have their meals together. We do not know how many separate cells were needed to provide for those who were living and working here. There was a guest-house which gave food and shelter to visitors and passers-by on their travels. The poor and hungry received a welcome, and were given some food and drink. The abbot had a special house. The scribes, who were in charge of the writing of books and the binding and decorating of the vellum pages, worked in a writing room called a 'scriptorium'.

The monastery at Kells encouraged many other activities in the whole neighbourhood. In fact, the monastery here soon became like a large town. Farming families, metal-workers, smiths and craftsmen came to live in and around the monastery.

Gold and silver ornamental work of great beauty made Kells famous. There was a regular industry organised for the making of pots and pans. Houses for poultry and cattle were also included among the buildings. Barns for the crops, and granaries, are also mentioned in descriptions of Kells. Young people were taught in a school run by the monks.

THE BOOK COVER

On one of the spare pages in the Book of Kells the name of a silversmith appears. He is called Sitric. He and his father, Aedha, are mentioned as craftsmen. Sitric's name is inscribed on the silver cover of the earliest bible manuscript that we have in Ireland. This is a beautiful manuscript known as the Cathach, sometimes called the Battle-psalter of Colmcille. It is splendidly designed with patterns of leaves and strange-looking animal shapes. The book-cover or *cumtach* is in the National Museum of Ireland.

We are not able to trace the name of the craftsman who worked on the cover of the Book of Kells.

Book covers were usually made of wood, perhaps from the yew tree or from oak, or sometimes of silver or gold. These covers were really cases or boxes in which the vellum leaves were kept. These boxes, decorated with plates of gold or silver, were like shrines. They showed that the book inside was thought to be of great importance. The Book of Kells was kept in a cover of beauty and dignity because it was a treasured reminder of Saint Columba. This souvenir or relic honoured one who loved books like this one and taught others to copy and care for manuscripts.

KELLS THROUGH THE AGES

Kells can be visited today. Stone crosses, a round tower and a little stone building with a very steep roof called 'the house of Colmcille' can be seen. These ancient stones remind us of the early days when the monks lived and worked here.

Kells used to be called 'Kells of the Kings', in Irish 'Cenannus na Ríg'. Near the monastery, beside the river Blackwater, was a royal fort, surrounded by a circular mound or rampart to protect it from robbers and enemies.

The Columban 'family' was given some land in the year 804 by the rulers of this fort. On this site a new monastery was built in 807 and its church was finished in 814. The abbot of Iona supervised the work. We read that his name was Cellach and that he retired when the building was completed.

Later, Kells became known as 'the splendour of Ireland'. For two hundred years it was the head of all the Columban monasteries in Ireland (A.D.950-1150). After this, Derry became the chief monastery.

THE BOOK OF KELLS IS STOLEN!

In the year A.D.1006-7 some very bad news was heard about the Book of Kells. The Annals of Ulster, in giving us year-by-year the history of important happenings in Ireland, tell us about this most unfortunate incident: 'The great gospel of Colmcille was stolen by night from the western sacristy of the great stone church of Cenannus.' The book was described as 'the chief treasure of the western world'. It had a golden cover which has never been

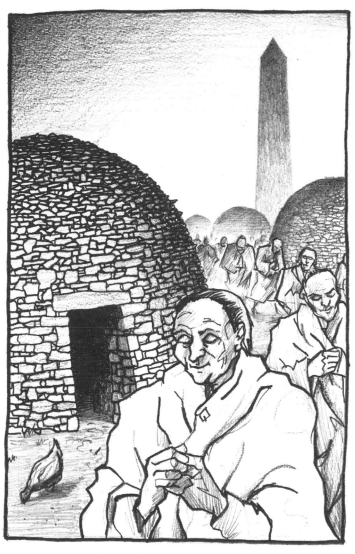

*Prayer came first in the life of the monastery, then study,
then work on the land. The monks sang psalms; 'every
day they gave thanks' to their Lord; 'seven times
a day' they praised God.*

found since that theft. The book itself was recovered more than two months later and the Annals tell us how this treasure was then protected and watched over in good times and in bad.

When the monastery's life came to an end in the twelfth century, the church at Kells belonged to the diocese of Kells which had recently been set up under the control of the bishop. (Until then Church affairs had been controlled by the abbey.) The book appears to have been kept in the parish church for many years after that. Since the year 1661 it has been in the library of Trinity College, Dublin. It was placed there by Bishop Henry Jones of Meath. He also brought the Book of Durrow to the library. Both these treasures have been in the university for more than three hundred years, where expert care is constantly taken to see that they are kept in the right kind of temperature and atmosphere. In this way, the skins, the writing and the colouring are all well preserved and kept in good order.

Why Was the Book of Kells Written?

In honour of God and St Columba

The last page of the Book of Kells has been lost, but if we could look at it we might find there the words: 'For God and Columba', written at the very end. Something like this was written in the Book of Lindisfarne, another gospel book of great beauty. The words 'For God and Cuthbert', are written there, as well as the names of the bishop Eadfrith who wrote it, Billfrith who decorated it, and Aldred who translated the Latin words into Anglo-Saxon which is written between the lines.

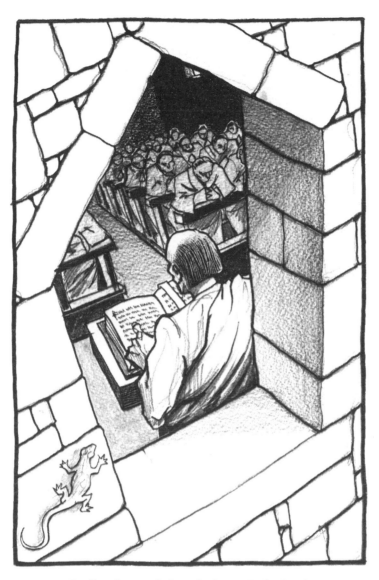

Reading the gospels from the lectern in the church.
There is a direction written in red (initium) on a page of
St John's Gospel in the Book of Kells, showing the
reader where to begin reading. (See page 24)

The Book of Kells was probably used at the worship of the community, because on one page there is a word written in red among the surrounding black words. This word in Latin is *'initium'*. It means 'the beginning'. Because it is in red letters, it would catch the eye of the reader who would then know the exact place to begin the reading. This 'red' word is called a 'rubric', and means an explanation or a guideline to help the reader. This rubric is found on page 327v in the Book of Kells (St John's Gospel, chapter II, verse 42).

There are signs and markings on other pages also which seem to link the book with the worship in the monastery (pages 292v and 177r).

A special book for a special monastery

The Book of Kells is full of variety. The pictures and patterns are much more numerous than in the other illuminated gospels. It is thought that the hands of many artists were at work through the pages. Yet there is a clear plan behind the surprises and the quaint little figures of people and angels, monsters and gentle animals. The four gospels are set out as one life of Christ.

It was perhaps the wish of Columba that there should be a richly illustrated gospel book in all the places where he had founded a community. Kells was for a time the chief centre of the Columban way of life in Ireland. The Book of Kells was an outstanding example of art and craft at that time. No other book that has survived is as large, as beautifully written or as richly decorated as the Book of Kells.

Other important monasteries also had very special books. When Gerald of Wales was on a visit to Ireland at the end of the twelfth century, he saw a beautiful Book of Kildare, which gave him great pleasure. The tiny patterns in particular astonished him. It is likely that this special book was made to honour Brigit, abbot of Kildare, and her abbey. Both Kells and Kildare were important enough to have works of art of such great value.

Understanding and teaching the Christian message

The pictures in the Book of Kells helped those who read the four gospels to understand the Christian message, even if the

book, written in Latin, was difficult to read. And for those who could not read at all the pictures were very important. The illustrations bring out the meaning of the text. The book is full of drawings that teach us and explain the words being read.

For example, we can see a cock and a hen and a chicken in between the lines of the parable of the sower. These pictures make us think of the fowl picking up the seeds that fell by the wayside.

In another place the capital letter N, standing for 'no man' (*nemo* in Latin) is shaped out of two little men. Their bodies and legs are twisted and turned to make the outline of the capital N. The two figures face each other. They are not at all friendly. In fact they are tugging at each other's beards! This letter N begins the well-known sentence: 'No man can serve two masters. He will either hate the one and love the other, or hold to the one and despise the other.' The little picture of the two men struggling gives us the clue to the words of Jesus which need to be thought about. Nothing seems to be going right between these two men! (See page 40)

When books about the bible are printed today the words that are difficult are often explained in written notes. Those who gave us the Book of Kells made the deep meanings of the gospel clear by using lively pictures that we will not easily forget.

How Was the Book of Kells Produced?

There are 680 pages in the book, that is to say, 340 calf-skin leaves, usually written on and decorated at both sides. About 150 calves were used to supply the material for this manuscript.

We do not know how much the book weighs. But a complete copy of it, with all the details reproduced in the same size, weighs about 20 pounds.

VELLUM

Calf-skin is sometimes called vellum, when it is made ready for writing. The skins of goats and sheep (called parchment) were also used for the making of books. Calf-skin had to be of very good quality for this work of art.

The vellum was made ready by cleaning. It would be dipped into water mixed with lime. After some weeks, when taken out, the skin would be scraped and all the rough bits of fur taken away. There is a flesh side and a hair side. The flesh side is smoother. This is scraped with a pumice stone and scraper and the skin is stretched and flattened, and a very fine surface prepared for the script.

There is a famous old riddle from hundreds of years back which tells how the calf-skin *feels* during all this preparation before it finds itself in a book! The riddle asks the question, 'Who am I?', then the skin speaks and we have to guess the answer. This is the riddle:

A enemy ended my life, deprived me of my physical strength; then he dipped me in water and drew me out again, and put me in the sun where I soon shed all my hair. After that the knife's sharp edge bit into me and all my blemishes were scraped away; fingers folded me and the bird's feather often moved over my brown surface, sprinkling meaningful marks. It swallowed more wood-dye and again

The making of vellum.
In the Book of Kells it is still possible to see which is the hair side and which the flesh side of the skins, made smooth after scraping and scrubbing, ready for the pen of the scribe.

travelled over me leaving black tracks. Then a man bound me, he stretched skin over me and adorned me with gold; thus I am enriched by the wondrous work of smiths, wound about with shining metal. Who am I?

WRITING TOOLS

The scribe wrote with a pen made out of a reed or a quill, or perhaps a goose feather. The monks who lived on islands, or by the side of a river at a point where the streams flow into the sea, would care for geese and swans and sea birds in a kind of bird sanctuary. These birds would provide them with feathers for pens.

Goose quills seem to have made good pens. They were not too soft and they lasted well. These quills had a tip, not too pointed but with a broad edge and slanted like a chisel's blade. This was a suitable instrument for outlining the letters.

INK

Ink was made out of the juices of plants, leaves and roots. Oak galls - those little brown growths on trees caused by insects or a kind of fungus - produced a very dark liquid. In the Book of Kells the colour of the ink varies - some of the letters are jet black to this day and have lasted in excellent condition, while in other cases the writing is more brown.

THE LETTERING

The pages of the book measure 13 1/2 inches in length and 9 1/2 inches wide. There are usually sixteen or seventeen lines of writing to a page. Towards the end of the book there are eighteen lines, with fewer decorations.

The vellum was carefully prepared for the writing. Pricks were made in the margins, spaced at regular intervals. These marks helped the ruling of double guidelines, drawn with a sharp instrument. Between these lines the letters were written.

The writing in the Book of Kells is very clear. The words are

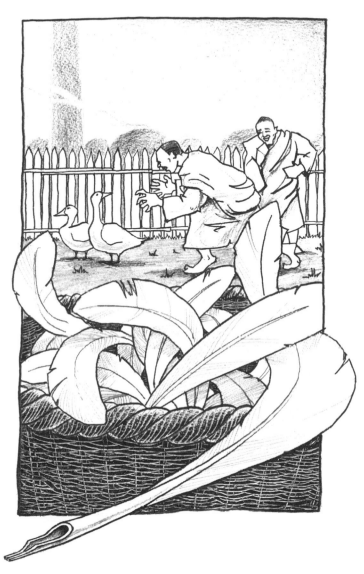

Gathering goose feathers for quills.
There was joy and good humour in the community, even when they
had run out of quills! A fresh supply was not far away for those
who lived close to nature.

usually written in full. Those words that are shortened are usually only the 'sacred names' - of God, Jesus, Christ, Holy Spirit and Lord. These were shortened for the sake of reverence, and a stroke above the word was a sign that the name was shortened. For example, Jesus was written $\overline{\text{IHS}}$, and Christ was shortened to $\overline{\text{XPS}}$. Sometimes, instead of a line drawn across the top, a fish would be drawn instead, like this: $\overset{\frown}{\text{IHS}}$. (The picture of a fish was a symbol for Jesus in very early Christian days: *ichthus* was the Greek words for 'fish', and each letter of this word was the first letter of each of the following words: Jesus Christ Son of God Saviour.)

The letters used in the written lines are called half-capitals, in between capital letters and small letters. They are well rounded and were probably written quite quickly and smoothly.

SECTIONS

When we look at our bibles of today we see that the gospels are divided into chapters and verses, each numbered so that we can find the section we want very quickly. But the Book of Kells was written long before this numbering was put into the scriptures. However, we soon notice that there are sections in the Book of Kells, and that these are clearly marked.

The first letter of each section is coloured and is shaped like an animal - a dog or a cat, twisting and turning to look like a letter. Or perhaps the letter has a human form, with arms stretched out and legs crossed. Or it might be like a plant or flower, with petals and stems woven into the shape of a letter. There are two thousand such capital letters scattered through the pages of the book. Each is different in shape and colour. No design is repeated. There is variety all the time. These charming and attractive letters divide the gospels into sections!

THE COLOURING

There are five main colours used in the painting of the Book of Kells. There are also browns and blacks, used to fill in the background of the full-page illustrations.

The make-up of the colours has been studied by chemists, but it is not always clear how these colours or pigments were prepared. The secret of their mixture has been lost without trace. Some people have tried to copy these colours, but it has not been

The preparation of inks and colours.
This took a lot of care (see pages 28, 30, 32). One scribe wrote
a verse about his quill and ink:
'Its slender beak spews bright ink -
a beetle-dark, shining draught.'

possible to imitate and reproduce the feel and the tone and the whole look of the twelve-hundred-year-old book.

Red The red is a tomato colour. It is made from red lead. The colour lies on top of the vellum and in some cases, through old age and wear and tear, little pieces have flaked off, leaving a white gap. It is a lasting colour and visitors admire its brightness. We see it at its best on the book binding in the hand of Christ (32v).

Yellow The yellow has a golden, shiny surface and is much used. It is called 'orpiment' - 'or' means gold and 'piment' refers to pigment. It is a mineral. Some of the soil in Ireland has this yellowy colour and may have been used in the preparation of colours used in the manuscripts. White-of-egg was used in preparing the pigment. The yellow substance bound together by the sticky egg-white would then be laid on the vellum with the flat edge of the palette knife, or some such tool. The XPI (34r) page owes its beauty to the orpiment that fills it (see pages 36, 37, 38).

Green The green has an emerald colour. It is made from copper. We see green on copper roofs and domes of churches. This is a colour which has lasted well. When put on the vellum it sinks right into the skin, and often shows on the other side. Like acid, it eats into the skin and in some places it makes a hole right through.

Imported Colours Some colours may have been brought into Ireland from outside. The purple, for example, is thought to have been prepared from the leaf of a plant found in Mediterranean countries, such as Italy. On the Mother and Child page (see page 35), the mingling of the green with several shades of purple makes this picture famous. The skill with which the artists blended the different colours without clash or lack of taste has often been admired. They had an eye for colour.

The blue which is used in some of the beautifully designed capital letters is thought to have come from Asia Minor or even further east. One writer has suggested that it came to Ireland from the Himalayan mountains of India! It may have been prepared from a precious stone called *lapis lazuli*.

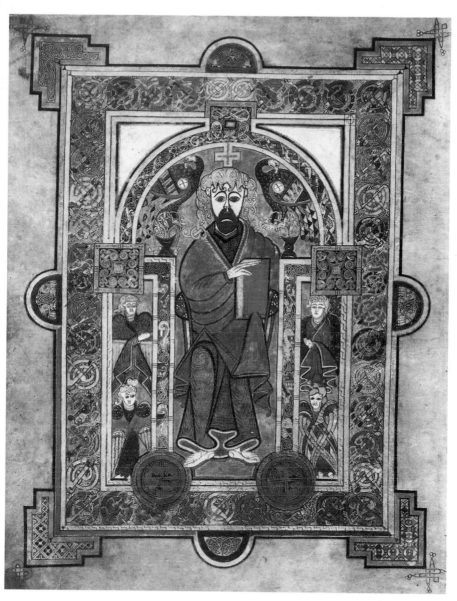

The Portrait of Christ (f. 32v)
This is a key page in the Book of Kells - the four gospels
are bringing news of one life. (See page 46)

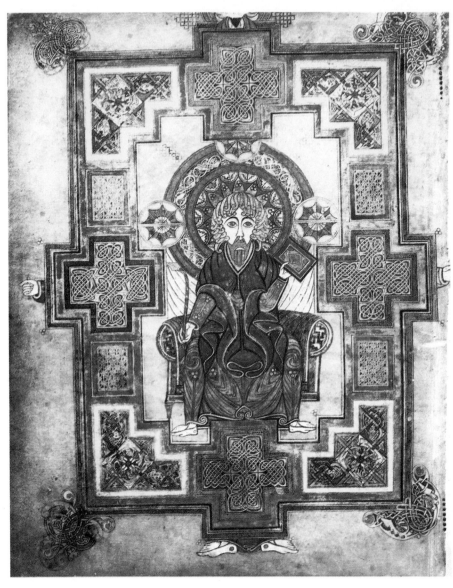

Portrait of John (f. 291v)
John is the evangelist of the fourth gospel. The head, hands and
feet of a hidden power behind the writer emerge at the edge of the picture's
frame. Unfortunately, this page was cut at one period in
history — note top and right-hand side. (See page 47)

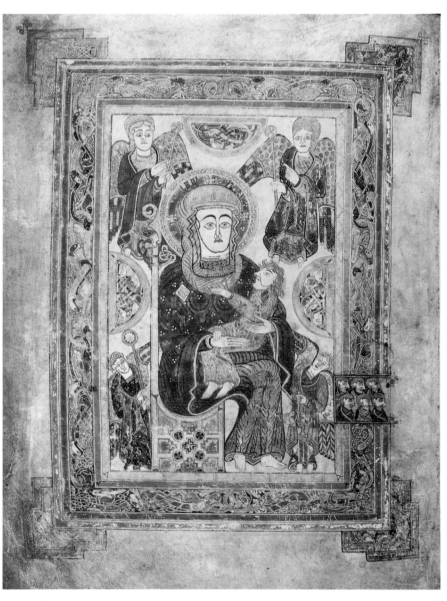

The Birth of Christ (f. 7v)
The Nativity scene, painted in solemn purple and emerald green,
speaks to us of the wonder and mystery of Christ's birth.
(See page 48)

35

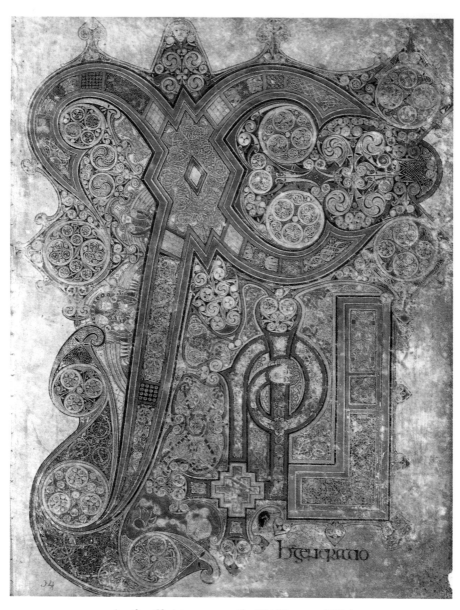

Another Christmas page - the Chi Rho page (f.34r)
This golden page tells us that Christmas is a new creation.
All kinds of life surround the great letter X (a Greek letter for Ch).
(See pages 49, 50)

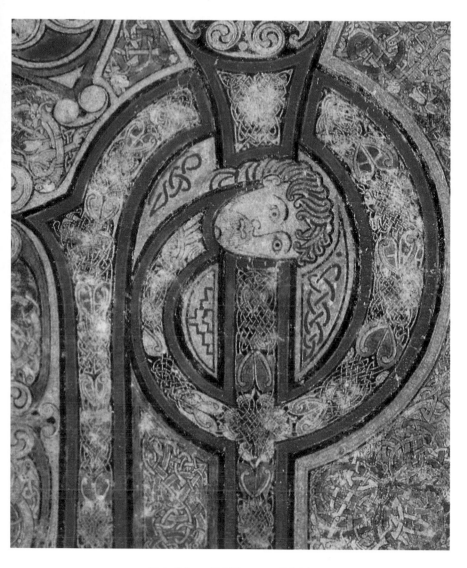

Detail from Chi Rho page (f. 34r)
The Greek letter 'r', shaped like P,
comes to life in human form.

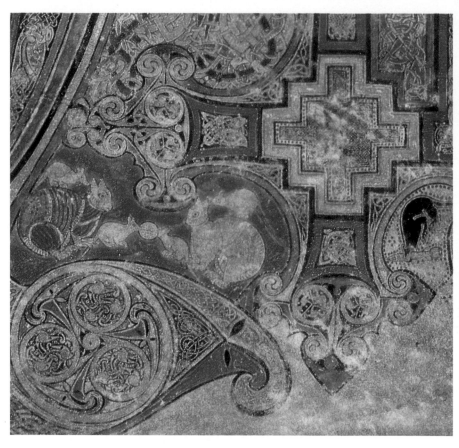

Details from Chi-Rho page (f. 34r)
The cat and kittens on the left, are sharing in the joy of Christmas.
The otter, too (right), takes part. The fish was an early Christian
symbol of Jesus Christ the Saviour. The initial letters of the words
Jesus Christ Son of God Saviour formed the Greek
word for 'fish' (ichthus). (See pages 49, 50)

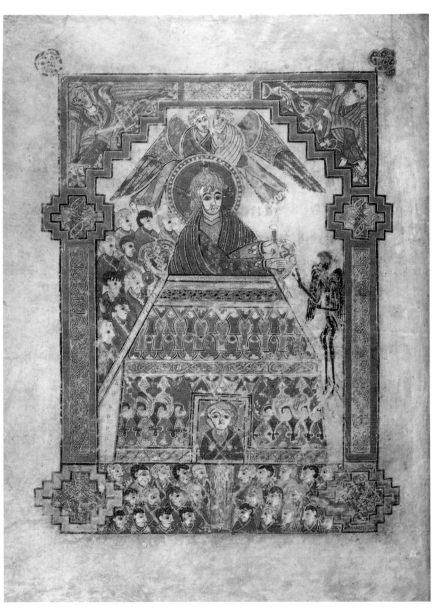

The Temptation of Christ (f. 202v)
Here we see a young Christ at the beginning of his ministry.
We sense his power as he faces his tempter.
(See page 52)

There are some well-known words in the lines of this page of script (f. 253v). Two little men form a capital N, and introduce the words: 'No man can serve two masters' (see page 25). It is also possible to see corrections made by another writer who has found mistakes of spelling and grammar.

PART 2

THE CONTENTS OF THE BOOK OF KELLS

The Four Evangelists

The Book of Kells is bound in four parts, but it is really one book. It is called a gospel book, and four different writers have reported the good news of one gospel. These are: Matthew, Mark, Luke and John.

When we look at one of the picture-pages near the beginning of the book, we see four figures, each one in a beautiful frame, with decorations and patterns and lovely designs all round the edges.

We can see a man, a lion, a calf and an eagle. They all have wings! They are called 'the gospel symbols'. On this page the four gospel-writers, or evangelists, are not mentioned by name but they are suggested by these pictures: Matthew (the man) Mark (the lion), Luke (the calf) and John (the eagle).

On other pages in the Book of Kells, at the beginning of each gospel, these 'four living creatures' remind us that there are really four stories told in the one Book of Kells. Each gospel-writer in his own way describes the life and teaching of Jesus Christ.

If we think about the four figures on the page, we will see that each one has a different kind of life. The man has a human life,

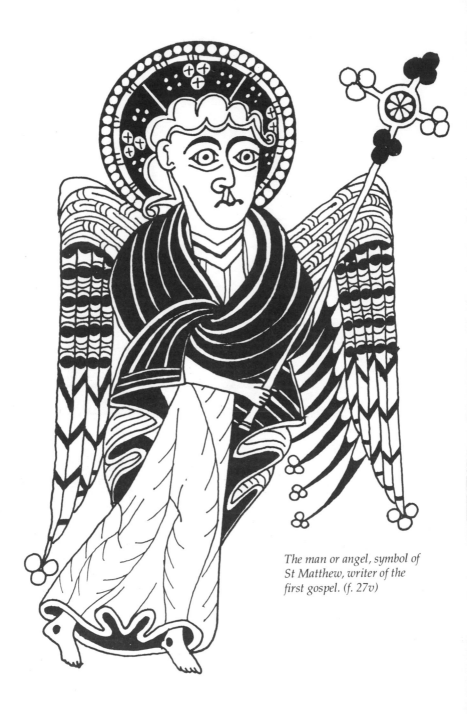

The man or angel, symbol of St Matthew, writer of the first gospel. (f. 27v)

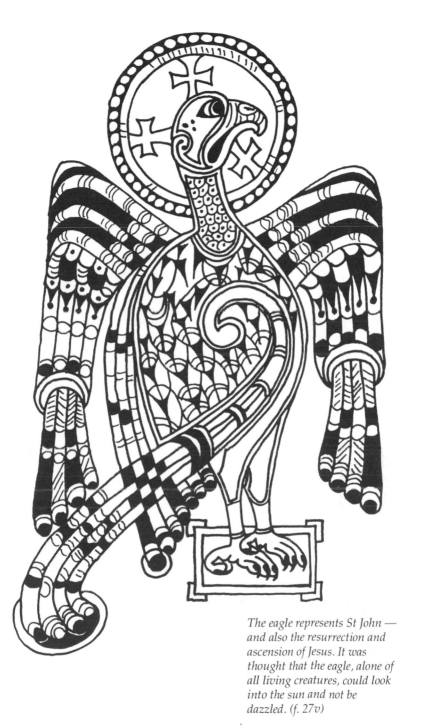

*The eagle represents St John —
and also the resurrection and
ascension of Jesus. It was
thought that the eagle, alone of
all living creatures, could look
into the sun and not be
dazzled. (f. 27v)*

like ours. The lion is a wild animal, with a wild life. The calf is found near homes and farms; it leads a tame life - a domestic animal. The eagle flies high like many birds of the air. We think of his bird life.

These types of life are described in the last book of the bible, the book called Revelation, in which the writer in his old age has a vision. The writer's name is John; he was on a beautiful, hilly island called Patmos, near Asia Minor, now Turkey, not far from a whole row of Greek islands. He saw into the future and pictured all the different kinds of life in a flash. Human beings, wild and tame animals and flying birds all have a place in one great world.

The four creatures shown on this page of the Book of Kells all have a round circle behind their heads. This is called a halo and is a sign of glory or saintliness (called after the round disc of the sun or moon). The halo shows that these creatures belong to God as well as to each other.

The painter in the Book of Kells makes one picture with four spaces, one for each figure. In the border decorations surrounding each figure, there are patterns, coloured in blue, red, yellow and brown. Some of the designs are formed out of twisted little men and biting dogs with long thin bodies, squirming and wriggling to make a very neat pattern. Look at the corner-piece of the picture frame at the left-hand top of the page and then see the very same dog-man twisting and twirling in the bottom right-hand corner. You really need a magnifying glass to see all the little bits of drawing and colour. Remember also that in the days when the book was made and coloured, there were no magnifying glasses for the workers, not even a pair of spectacles!

The eagle seems to be a special creature - he has three crosses in his halo; the calf has one; the lion has none. The man has some groups of three purply circles in his halo; each circle is marked with a tiny cross. The painter loved to have separate and special designs for each one. He also filled the edges with ten and more pairs of patterns; those on one side of the picture match the same sort of patterns on the other side, to balance the whole design.

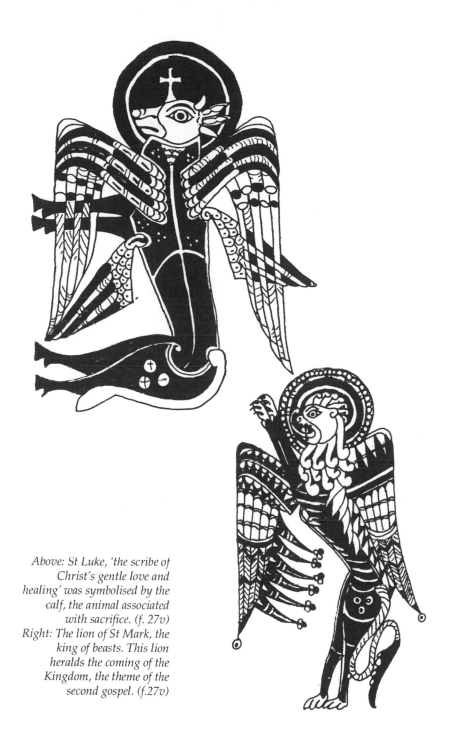

Above: St Luke, 'the scribe of Christ's gentle love and healing' was symbolised by the calf, the animal associated with sacrifice. (f. 27v)
Right: The lion of St Mark, the king of beasts. This lion heralds the coming of the Kingdom, the theme of the second gospel. (f.27v)

45

The Full-page Portraits:
Christ, Matthew, John

There are three full-page portraits in the Book of Kells. Near the beginning, there is a picture of Jesus Christ (32v), and one of St Matthew, the writer of the first of the four gospels (28v). There is also a portrait of St John (291v).

PORTRAIT OF CHRIST

(See page 33)

The portrait of Christ shows our Lord sitting on a throne. He holds a book, bound with a red cover, in one hand and with his other hand he seems to be giving us a blessing. His robes and the style of his flowing hair and dark beard are like other pictures of Christ found on the walls of churches or in books in many parts of the east, such as Egypt or Asia Minor.

Two beautiful peacocks, with many-coloured feathers, surround Christ's head. These peacocks are standing in vases from which vine-leaves with grapes are growing. On the breast of the birds is a little white disc, marked with a red cross. It is thought that the discs and grapes are symbols of the bread and wine, consecrated in the eucharist (holy communion). Below the peacocks, are figures of men and angels. The angels have wings. All four figures worship the central figure. Peacocks often stood for immortality or life-everlasting in the art of this period in the east. The whole page is framed with brilliant colouring. Red, blue, and yellow circles (called 'roundels') are drawn with ribbon interlacing. One roundel is joined to the next, as our eye follows the rhythm and flow of the pattern, which can be traced through all four sides of the frame. The cross placed over the head of the Christ is another sign that this portrait is different from the portraits of the evangelists (or gospel-writers).

PORTRAIT OF MATTHEW

(S e e p a g e 1)

The face of Matthew is very like the face of Christ. In those early days, the man figure was drawn and painted in rather a stiff attitude. There was little feeling of movement. We can see from the position of the feet that Matthew stands as still as a statue! He holds a book, probably the gospel-book that bears his name. He is surrounded by the animal symbols of the other three gospels. On either side of his head, a lion represents St Mark. Lower on the left is a calf (St Luke) and on the right the eagle of St John. Those three animals help us to guess that the central figure is Matthew. Again, the border-line ornament is packed with circles and half-circles. Little serpentine, snakelike, coiling creatures with sharp, bright eyes bring life and movement to the page.

PORTRAIT OF JOHN

(S e e p a g e 3 4)

John is seated with a pen in his hand. The pen appears to be a reed rather than a quill in this picture. Its point is about to be dipped into an ink-horn beside the right foot of the evangelist.

John has a much larger halo than is usual. It consists of two round discs, elaborately decorated in the outer ring with writhing, wriggling animal interlacing, while the inner circle has step-patterns and clusters of trefoil (they look like shamrocks) neatly arranged all round in a carefully spaced pattern.

Beside the great frame of the page, at the centre of each side, a head at the top is visible and a pair of feet at the bottom, while at each side a hand can be traced. It looks as if 'one mightier than John' is behind him as he writes, inspiring and supporting him!

In the panels of the frame are some fine examples of interlace. The lines, some as thin as a thread, are interwoven. Others are broader, and like ribbons. They cross each other, over and under, with neat tracery. Some of the lines are rounded and flowing. In other panels, they are drawn with sharp corners; sometimes these angular patterns are described as fretwork interlace.

Full-page Scenes from
the Life of Christ

No one knows how many painters and artists had a share in the colouring and designing of the Book of Kells. There are many different styles. There may have been four or five different painters. It is thought that a 'master-mind' planned the whole book and the colouring of it. Then separate artists worked on their own, according to the overall plan, and put themselves and their imagination into what they were painting.

Perhaps we could call the painters after the style of the pages they illustrated. One might be described as 'the portrait painter'. Another who illustrated scenes from the life of Jesus has been called 'the illustrator'. Yet another sort of designer seemed to use instruments like rulers for the straight lines, and compasses for drawing the circles; he is known as the geometrician (the 'geometry monk'!). Some pages have a lovely golden glow; these have been painted by someone who was fond of the yellow (orpiment) colour. There is no gold-leaf, shining like tinselly metal from the page, but the worker in yellow orpiment has been called 'the goldsmith'.

BIRTH OF CHRIST

(See page 35-38)

When we look at the story of Jesus's life in the great, decorated pages of the Book of Kells, we find two illustrations of Christ's birthday.

One page (7v) shows the mother of our Lord, Mary, with the baby Jesus on her knee. Mary, robed in purple of different shades, is majestic and dignified. She is seated on a throne elaborately ornamented. The baby's wise little face looks towards her as she clasps him close. The babe has one hand on the mother's right hand and the other on her breast. It is a very solemn picture and does not at first sight suggest our usual greeting: 'a happy Christmas'. As we look at the mother and child for a little longer, we see that the picture is telling us that something very important

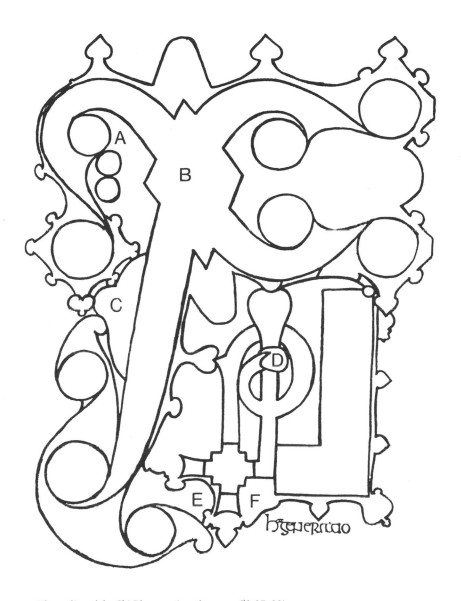

The outline of the Chi Rho page (see also pages 36, 37, 38).
A: Tiny insect life — a pair of moths (or perhaps a butterfly).
B: In this small space are four human heads, four animals, twelve birds, some serpents.
C: Two companions in perfect harmony, beside the great X.
D: The P (Greek r) is rounded off with a human head. Many capital letters in the Book of Kells spring to life in this way.
E and F: Cats, kittens and the otter share in the joy of Christmas.

has happened: a very special child has been born. The two angels above the mother and child are smiling and welcoming. The two angels in the lower half of the picture are peeping round the corners of the chair. They are excited and full of curiosity. As for the two little tumbling figures in both the right- and left-hand central panels between the angels, it can only be said that they are dancing for joy. One of the partners in each case is standing on his head! The six little heads in the right-hand lower corner of the page are very like the carved faces on the Irish high crosses. These are the people whom Christ came to save.

The other Christmas page (see page 36) has quite a different look. A large letter shaped like an X sweeps across the surface. Surrounding the curved flowing lines of this initial of Christ are all sorts of living things. Apart from tiny human figures on the left-hand side, we can see an otter bending down with a fish in its mouth at the bottom of the page (see page 38). Near the otter, to the left, two cats sit facing each other, with their kittens. Two kittens have climbed on to the backs of the mother-cats. Two are sharing the little round white disc which they nibble. This disc, marked with a cross, suggests the sacred communion bread of the eucharist. A butterfly with spreading wings is tucked away near the top right-hand corner of the page. The longer we look at this golden-yellow Christmas page, the more fascinating details of circles, spirals and gracefully curved lines give us the feeling of the new life of peace and happiness that Christ came to bring.

There are very few words on this page. Right on the bottom line is the Latin word for 'the birth' (*generatio*) and then the rest of the page is filled with the letters XPI, which mean 'of Christ'. The X is the Greek letter for 'Ch'; the P is a Greek 'r'; and the meaning of XPI (Chi Rho) is 'Christi' (of Christ).

This symbol of Christ, sometimes drawn like this: ☧ , was often seen on the walls of churches or on carved crosses. It still appears today in stained glass windows and in much Christian art. In the top left-hand section of the page, finely drawn circles enclose other smaller circles, and these smaller circles have even tinier circles inside them. We wonder what these circles mean. Some people think of the idea of 'three in one'; others see a perfect unity, with all the pieces fitting together in harmony to make a perfect whole.

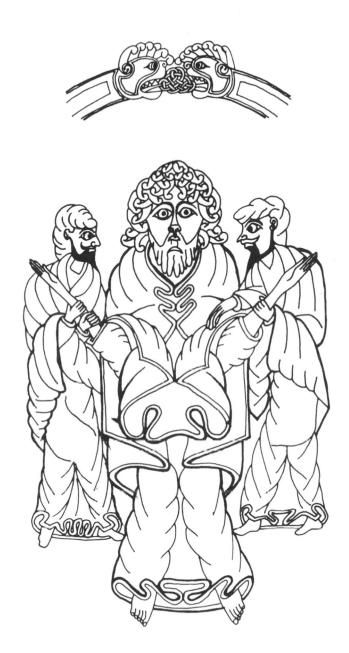

Christ arrested in the Garden of Gethsemane (f. 114r). Some see the figures at his side not as soldiers capturing him but as supporters strengthening him as he prays.

THE TEMPTATION

(See page 39)'
A full-page picture of Jesus being tempted by the devil shows us another moment in his life. Jesus is on the temple roof. His face is young-looking, with only the beginnings of a beard on his chin. He is holding a roll (or scroll) of scripture in his hand and is answering the dark, bony figure of Satan, whose dark wings look rather frightening and evil. Jesus, however, has no fear. He is large and strong, while the devil is thin and is not winning in the struggle. Angels surround the head of Jesus and give him help and support. Crowds of people gather round the door of the temple, where someone on guard with two rods, held crosswise, keeps watch. The temple is not so much like the famous building in Jerusalem. It is more like a small early Irish stone church, with a steep roof and slips of wood called shingles hanging from it, instead of tiles, to keep the rain-drops from seeping through. The temple building in this picture is shaped like the 'house of Colmcille' which can still be visited today in Kells.

The whole picture reminds us of the scene described in St Luke's Gospel (4:9) when Jesus was led to Jerusalem and made to stand on the high parapet (pinnacle) of the temple. The tempter's words to Jesus are: 'Throw yourself down. God will put his angels in charge of you to guard you. They will hold you up on their hands in case you hurt your foot against a stone.' Jesus answered: 'You must not put the Lord your God to the test.' After that, the devil left him.

ARREST OF JESUS

The arrest of Jesus by armed men in the olive-tree orchard or Garden of Gethsemane is shown on another picture page (114r). This garden was at the foot of the Mount of Olives, a hill just outside Jerusalem near a stream called the Kidron. Some think that this picture shows Jesus, praying in the garden, shortly before he was taken prisoner. His well-known prayer addressed to his Father was a very sad one as he faced death. 'If it is possible,' he prayed, 'let this cup [of sorrow] pass me by.' The whole picture is full of sadness. In the centre of the arch that surrounds the words about the Mount of Olives, two fierce monsters, with flashing eyes, growl at each other. The animals are like lions or bark-

ing dogs. Many such angry, roaring beasts appear in different places through the Book of Kells. They suggest trouble, pain, or punishment. Evil, as well as good, is found in the story of the book but in the end, good wins a victory over evil. On this page it is clear that Jesus, who is good and just, is facing a time which is both bad and painful for him (page 51).

THE CRUCIFIXION AND RESURRECTION

There are two pages which have the message of Good Friday and Easter Day. The words on these pages (124r and 285r) are written in a special way. The description of the Crucifixion is set out in the form of a cross. The scribe seems to feel that he should not write in straight lines as he thinks about Jesus hanging on a cross between two thieves. The words 'Christ [XPI] and with him two robbers' are shaped like a diagonal or St. Andrew's Cross. There is no picture of the scene on Calvary, the hill where Jesus was crucified. This way of writing with criss-cross words makes a great impression on the readers. The large capital 'I' formed out of the twisted body of a monster with flashing eye and long red tongue, pushing and straining, makes us feel the terror of this cruel death.

The Easter or Resurrection page is also a surprising one (see page 54). There is no picture of Christ rising from the grave. The single word 'UNA' is placed in the centre of the page. It means 'day number one' or 'the first day of the week'. Sunday, of course, the first day of the week, is the day on which the Resurrection of Jesus is celebrated. Angels are guarding the capital letter U, one at each of its four corners. It looks at first like a dark, dull page, but out of the dim gloom the feet, the hands and the faces of the four angels, painted with white lead, shine out, gleaming and bright. These angels are looking up and out from the page. They make us think that something very important has happened. They are alive and alert, not asleep, nor downcast. Their message is: 'Christ is risen; he is not here. Why look for the living among the dead?' We also observe, in the top right-hand corner, that the fierce monster is speeding away out of the picture. The power of this enemy has been overcome. The beast is on his way out, defeated. He, unlike the dragons and gargoyle-like creatures that roared and raged at the Crucifixion, is moving off, silent and ter-

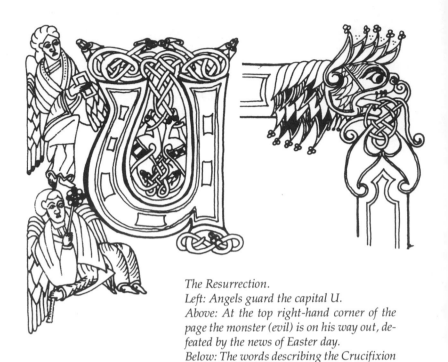

The Resurrection.
Left: Angels guard the capital U.
Above: At the top right-hand corner of the page the monster (evil) is on his way out, defeated by the news of Easter day.
Below: The words describing the Crucifixion are written in the form of a cross.

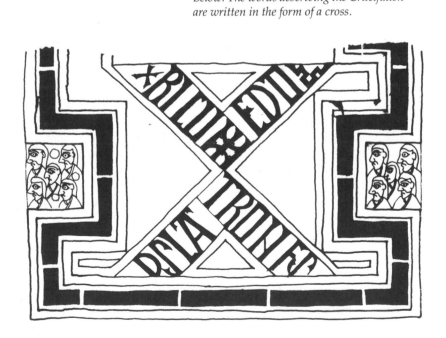

rified. The capital U, with a tangle of graceful birds in the heart of the letter, and surrounded by guardian angels, helps us to have a picture in our minds of the empty tomb on the first Easter day.

THE CROSS

Earlier in the Book of Kells, on the page opposite the Portrait of Christ, is a large eight-circled cross (33r). The yellow and brown 'autumn' colouring gives the page a shining glow, like polished metal, now golden, now bronzed. The cross is framed with a great variety of decoration - round patterns in the shape of a trumpet, combined with spiral threads and weaving ribbons, make our heads whirl round. Those who designed this decoration never lost their way as they threaded through the loops and the twists. There are four special details, all with the same design, added to the centre of each of the four sides of the rectangular frame. These little ornaments show two double-headed monsters struggling as they tussle with each other; with their coiling tongues lashing, they pull and strain at a tangle of thread between them. Their golden yellow crests touch each other and the whole scene is one of tension. Beside the stillness and unchanging character of the cross, life's struggles find a solution and an answer. The tangle of thread between the tugging forces of the beasts is woven into a perfect square, a well-finished pattern!

One of the circles of the eight-circled cross which faces the portrait of Christ (see page 33). The design of the cross has influenced silver and bronze book covers of the same period.

55

Christ's Family Tree

abræcham

Five pages are used for the list of names set out in the family tree (or genealogical table). These appear in St Luke's Gospel. From Joseph, the husband of Mary, the names are traced back to the days of Abraham, Isaac and Jacob, and right back further still to Seth, the son of Adam, and Adam, the son of God.

Instead of writing out an ordinary list of names, the artist of the Book of Kells made a separate picture with a special colour scheme for each of the five pages. On the first page he decorated the first letter of each phrase 'who was the son of ...' in the long row of generations. A bearded figure, a sort of father-figure, is at the top and then down the line snapping, lively dogs put life into the formal, lifeless capital letters. The artist turns the long list of names into a line of life.

At the foot of the first page a little warrior-soldier sits on the letter h. This letter h is stretched out to reach the margin and to make the border straight and even. The soldier with his spear and tiny round shield has his foot in the h, which is made long to look like a trap. The soldier's foot is caught in it. As we look at it, we think that there must be a story behind it.

Top: Abraham sits on his own name in the family tree which links Jesus to him.
Above: This patterned panel suggests 'everlasting life', as the plant with its branches continues to spread at the conclusion of the family tree.

Above: A bird instead of a bracket! Right: This thin animal is in the margin of the page describing the raising of Lazarus from the dead. He adds a sense of awe and wonder. The third animal sits at the end of a paragraph (marked by the three square dots). It adds colour and life.

Below: A dog guards a straying syllable in the word 'excelsis'. This is from the Palm Sunday cry: 'Hosanna in excelsis Deo' - Hosanna in the highest.

On another page of names, we see a little old man with a cup in his hand, sitting on the word 'Abraham'. We can guess who this old man was meant to be. On yet another page is a golden-looking mermaid. The human figure ends up with a fishy tail.

At the very end, there is a decorated panel, filled with rich colouring. Since the last name in the list of generations is God, the panel, consisting of two sections, acts as a kind of curtain behind which we see the bearded 'Almighty' appearing over the top and then below we can just see two feet peeping out. The left-hand panel of this screen that curtains off the Almighty might be called 'eternal life'. It consists of two birds, interlocked and intertwined, their beaks biting each other's feathered tails. You cannot find the beginning or the end. Eternity has no beginning or end. The other panel is different. In the centre of it is a vase from which the branches of a vine spread out, left and right; very small branches sprout and spring from the thicker ones near the vase which holds them. Perhaps, if the left-hand panel suggests eternity, the right-hand panel might be called 'everlasting life', as the branches, like the branches of a family tree, spread out and go on growing (202r).

The Little Animals

The scribes loved to include all sorts of small pictures as they wrote. Animals of many kinds appear between the lines through the Book of Kells. Cats and dogs chase across the vellum. Fish and snaky scorpions surround the letters. Some beautiful birds fly down and land on top of certain words. Sometimes these miniature pictures seem to have a meaning and a use. At other times, it is probable that they are put in for fun or as a joke. The writers show their sense of fun and humour in this way.

Little animals are used now and then instead of brackets. If part of a word has to be separated from the whole word because it does not fit at the end of a line, that part or syllable would be placed in the space over the line or else tucked carefully under the unfinished word. The letter or the syllable would then be guarded by the outstretched wing of a bird or by the front paws of an oncoming dog. And so the reader would not miss them.

There is one place where a dog lies on his back with his legs in the air and the little word between these legs is protected and not lost. The scribes, coming to the end of the line and not want-

Capital letters (clockwise from top left)
T for the Latin word Tunc (Then). The
animal looks down at the next 'Tunc'
where an equally ferocious animal
looks up. They are in the scene of
Christ's trial before Pilate.
Struggling animals shape the letters DI,
part of the Latin word Dico (I say).
Another DI, patterned in milder style.
The letter A, abstract and
geometrical in design.
M is for Matthew.

ing to allow the word to spill over into the margin, used to say about the extra letters as they tried to fit them in above or below the line, 'I must put the head under the wing', or again, 'I must take the turn under the path'.

The Capital Letters

The capital letters at the beginning of each section or paragraph are all ornamented. Sometimes they are shaped out of animal figures; there might be one or two dogs, or even three, all locked together to form the letter. Some have a human outline. Others are twisted plants, leaves and little branches, shaping all sorts of letters. Some capitals are much more formal and consist of straight lines, perhaps ruled with instruments.

The capital letters are in themselves little pictures. Occasionally they are connected with the written words which they introduce. For example, the saying 'Remember Lot's wife' shows a little white salty female face looking backwards in the heart of the capital letter. Another example is found in the story about those who ask Jesus a difficult and catchy question about paying tax to the Roman emperor (Caesar). This is a trick question and the capital letter 'T' at the beginning of the paragraph is made out of a little man with his neck twisted and straining, and his arms stretched out, through a tangle of ribbon, reaching to catch a beautiful bird flying towards him. The idea of 'catching' or 'entangling' is pictured in the capital letter to match the story.

In the Sermon on the Mount (Matthew, Chapter 5), the whole series of capital Bs for 'Blessed' (the Beatitudes) are colourfully decorated. There are eight in all: 'Blessed are the poor in spirit ... Blessed are the mourners ... Blessed are the peace-makers ...

Four of the Bs are in the shape of swans with long necks to make the right outline of the letter. The first four are human figures with suitable twisting to form a set of Bs.

Four human figures and four swans shape the eight Bs of the Beatitudes, from the Sermon on the Mount.

*Capital letters
(top to bottom):
VA, part of the word Vae,
Latin for 'woe'.
T, capital for Tunc, 'then'.
ET, Latin for 'and'.*

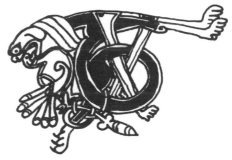

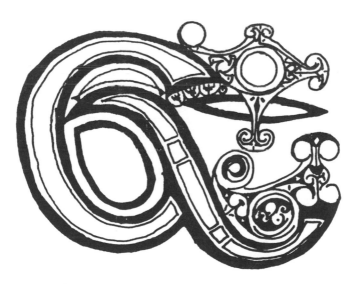

PART 3

THE PRESENT HOME OF THE BOOK OF KELLS

Trinity College

We left the traffic in Dublin's busy College Green. Like many other visitors we went in search of the Book of Kells. We made our way through the archway of Trinity College's front gate and found ourselves in the square. There were buildings on every side and cobblestones under our feet.

A signpost carried the name of the Book of Kells on its pointer. It directed us to the Old Library. Stretching out before our eyes were twenty-seven long, shining windows on each of the three main storeys of the library's magnificent front. Inside, and over-flowing into other buildings nearby, were two and a half million books! We had come to look at one of these books, a very special one.

THE LONG ROOM

We climbed the stairs and came at last to the Long Room. This is the longest room in any library in Ireland. Some say it is longer than any of the large library rooms in the whole of Europe.

We walked past some very high bookshelves reaching right up to the ceiling. They were packed with books of different sizes. Many had brown leather covers. All were marked with letters of the alphabet and with numbers. There were more letters painted on the wooden pillars. These pillars gave support to the shelves

and had some beautifully carved ornament. The letters and numbers marked the exact spot where each book could be found.

In the nooks and corners among the bookcases were sloping desks. In these alcoves or bays the members of the college used to study long ago. The sun's rays were streaming through the tall windows. We saw one or two readers, perched on high ladders, reaching for some books.

There was a gallery running the whole way round this great room which measures just over 209 feet in length and is 40 feet 3 inches wide. A spiral staircase twists its way to the gallery at one end; at the furthest end of the Long Room two oak staircases, one for each side, lie tucked in neatly behind the shelves. Both sides of the room are lined all the way along with white marble 'heads and shoulders' of famous writers and personalities from the past. These sculptured busts seem to guard, like sentries, the entrance to each alcove.

RARE BOOKS

In the middle of the Long Room under the high ceiling, rounded like a barrel and vaulted in wood, we approached some showcases. They were like tables with glass tops. They were covered with curtains and firmly locked. If we drew the curtains to one side we would be able to see some very unusual and rare books. Some are very old - the oldest date from 1300 years ago.

The Book of Kells is the largest and most colourful of these ancient books. It was written and illustrated by hand. This beautifully painted and decorated manuscript is about 1200 years old. The printing of books began in Europe at a much later date, about 530 years ago.

The lovely reds, blues, greens, golden yellows and purples are kept shaded by the curtains from the bright daylight. Otherwise the colours would lose their bright glow. This was the book we had come to see.

There are seven bible manuscripts which date from as long ago as twelve or thirteen hundred years. The Book of Kells is the largest and most richly coloured of them all.

The Book of Durrow, like the Book of Kells, contains the four gospels of the New Testament. It is smaller and about 150 years older than the Book of Kells. Some of its handsome designs of pages with circles and spirals make lovely patterns. They have

The Long Room, Trinity College Dublin
This room is 209 feet 3 inches long and 40 feet 3 inches wide. Architect
Thomas Burgh; builders H. and M. Darley. Date 1732. Alterations were
made to the ceiling - a wooden barrel-vault was fitted by
Sir Thomas Deane and B. Woodward in 1860.

been copied by the artists of the Book of Kells. The Book of Durrow, for this reason, has been called the 'elder sister of the Book of Kells'.

Other manuscripts often shown in the Long Room include much smaller books called 'pocket gospels'. The Book of Dimma and the Book of Mulling or Moling are both small enough to be slipped into a hand-satchel by a member of the monastery. They both contain prayers as well as gospels and were used by monks on their visits to churches and family homes.

Only one of this collection of handwritten and handdecorated books contains a complete New Testament, consisting of some twenty-seven books. This manuscript is called the Book of Armagh and is smaller in size than the Book of Kells. Written at about the same time, it contains much more of the bible than any of the other books. In addition it contains between its covers an early copy of St Patrick's Confession and other writings about Ireland's apostle.

PART IV

CONCLUSION

A Work of Art

We have only had time to see a small part of this great book. Something on every page catches the eye. A little colour here and a pattern of dots there and the finest of lines fill many a corner of the vellum.

We wonder how long it took the writers and painters to work on this masterpiece. Someone who has studied the details of the manuscript guessed that the work might have gone on for thirty years. Even so, the book is unfinished.

One little corner filled with those ribbon-like threads, which are woven into a pattern, might have kept one of the artist-monks fully occupied for a month! This interlacing of threads, ribbons, and spirals was carefully rounded off. No loop was missed. The lines were drawn over, under, and over again without any blur. We might say, they never dropped a stitch. The finest of red dots and brownish lines, when looked at with a magnifying glass, are seen to be perfectly in place.

The writing was quite swiftly done. If a script-writer today manages to write 180 words in an hour, or spends a quarter of an hour over six lines in the style of the Book of Kells, it is very likely that the monks of that time wrote even faster.

The actual writing was strenuous and the monks often admitted that they were tired. Some remarks about their feelings are found scattered through other old manuscripts, but not in the Book of Kells. One scribe noticed that, while only three fingers did the writing, his whole body was working. Another tells us

*Lively and intricate interlace decorating the opening words
of St Mark's Gospel.*

what it is like to reach the last page when copying a book: 'As the
harbour is sweet to the sailor,' he wrote, 'so is the last verse to the
writer.' At the very end of the book, we often find a prayer, thank-
ing God and praising him.

The monks, who were only human, sometimes complained
and in the margins of the page we might come across this sort of
little scribbled note: 'I am cold and weary, ink is bad, vellum is
rough and wrinkled, the day is dark.' We feel sorry for one lone-
ly scribe who put down his thoughts in a corner of the page: 'My
only friend is God: I have no drinking-cup or goblet but my shoe'!
Since the monks worked in silence, these little notes may really
have been conversations with a nearby brother.

JOKES

In the Book of Kells there are no amusing remarks, but there are some very funny little pictures. We can be sure that the monks enjoyed a good laugh. They were, of course, very serious when they dealt with the words of the bible, but they were quite ready to make a joke about their own lives and their animal pets. Life for them was a life given to God, and the lively animals that they put into their pictures show us that they found great joy in God's 'creatures great and small'.

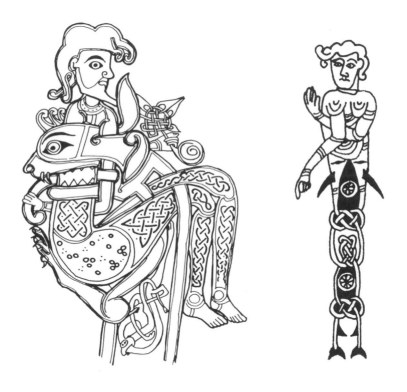

*Left: This figure, perhaps of St Mark, is on the top right-hand corner of the
first page of his gospel. He meets the attack of a hostile monster
by calmly holding the beast's tongue to control him.
Right: A merman, on a golden yellow page containing a list of names in the
family tree , adds graceful decoration to the page.*

We look back

Looking back through the Book of Kells we remember the different styles of drawing. There is a very beautiful capital M decorated with bright colours to begin the Magnificat, that song of the Virgin Mary: 'My soul doth magnify the Lord'. She sang it when she had news about the baby that would be born to her. This capital letter is designed with two large curving loops to shape the M. In the left-hand loop, we can see a mother bird feeding a baby bird; two gaping beaks are meeting and a beautiful picture from nature is fitted neatly into the small, circular space. A formal letter thus becomes a scene from real life in God's creation.

Quite a different style of decoration is used when the parable of the Prodigal Son is written. This famous story is about a wasted life. The son who leaves his father's home is wild and foolish. In the margin, the colouring of the letters is bright, with flashing reds and bright blues. A whole group of animals, biting and

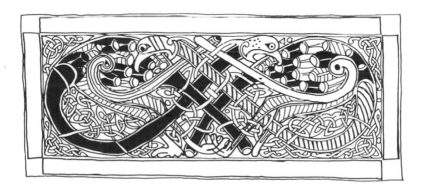

Eternity - with no beginning and no end - is the tail-piece to the genealogical table. (See page 58)

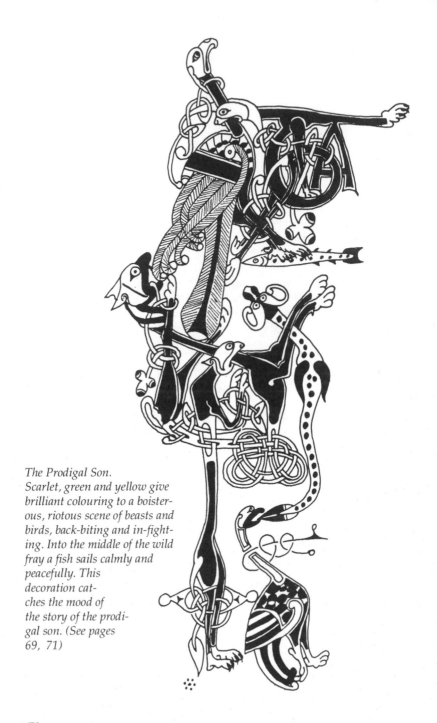

The Prodigal Son.
Scarlet, green and yellow give
brilliant colouring to a boister-
ous, riotous scene of beasts and
birds, back-biting and in-fight-
ing. Into the middle of the wild
fray a fish sails calmly and
peacefully. This
decoration cat-
ches the mood of
the story of the prodi-
gal son. (See pages
69, 71)

ferocious, leap in and out of the letters. There is a riot of colour and also a fierce battle with dogs attacking birds, and great confusion. The artist catches the spirit of the wild life of the son, when he was lost, before he was found again.

At the end, we find that we have made friends with these writers and makers of fascinating designs and thousands of pictures. They have allowed us to share in the hard work, but also in the happiness of the life they spent in those little cells 'for God and Colmcille'. The little eyes of the tumbling dogs and frolicking cats are still twinkling, as we look through the pages of the Book of Kells.

Acknowledgements

The author and publisher thank the Board of Trinity College for
permission to reproduce illustrations from the Book of Kells
in colour. We thank Patrick Flower for permission to use the
'Pangur Bán' translation by Robin Flower. The quotation
'An enemy ended my life . . . (page 26) is taken from the
tenth-century collection known as the Exeter Book,
now in the library of Exeter Cathedral.